The Thomas Jefferson Building,
The Library of Congress

ART SPACES

Blaine Marshall and Alexander Hovan

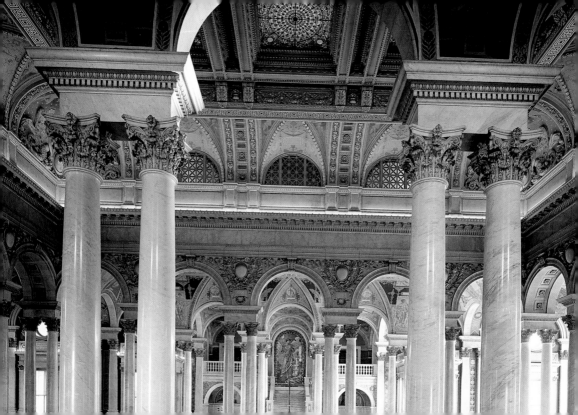

The Thomas Jefferson Building

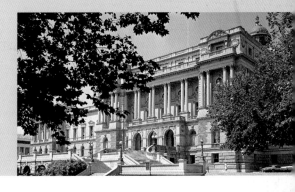

The Thomas Jefferson Building, the symbol and soul of the Library of Congress, commands a view across First Street to the United States Capitol Building in Washington, D.C., where the seeds of the Library were first planted in 1800. Begun in late 1886 and completed in 1897, the building pays homage to its cultural antecedents, the national libraries of England and France, through both its design and purpose. Known as the Library of Congress, or Main, Building until 1980, the Jefferson Building was designed to house America's national library. The embellishments that complete the building serve to showcase the art and culture of the growing Republic. The gilded torch that crowns the 195-foot high dome represents learning, a theme central to the Library's purpose and one that is reflected consistently throughout the inside and outside of the edifice. The decorations, modeled on elements of the 1893 World's Columbian Exposition in Chicago, celebrate America's unique cultural ambition.

The grand approach to the building suggests the innumerable treasures within. At the base of a wide

∧ View of the west façade of the main entrance of the Jefferson Building.

< Interior view of the Great Hall of the Jefferson Building.

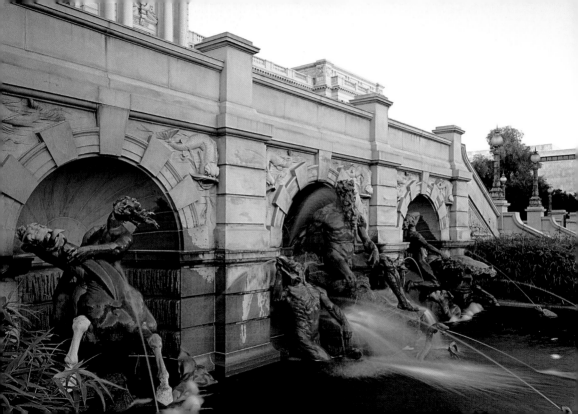

porch sits a fountain, designed by Roland Hinton Perry, which depicts the figure of King Neptune in bronze. It occupies a semicircular basin fifty feet wide and contains a dozen sculptures and three deep niches, with the colossal and muscular figure of the classic sea god Neptune seated at the center. At the front of each flanking niche sea nymphs sit upon sea-horses, who appear to writhe as jets of water emit a constant spray upon them. The stone of the niches themselves suggests grottoes, worn by the sea and articulated by stalactites, as though formed by the constant drip of water.

Once on the porch above the fountain, reached by climbing one of two flights of steps constructed of New Hampshire granite, the visitor faces another central stairway. Underneath this stairway, a carriageway leads to the ground floor entrance, where staff, researchers, and visitors enter today. At the top of this stairway, though, lies a grand ceremonial entrance consisting of three archways each inset with a massive bronze double door. Nine busts, each situated in a portico, overlook the entrance on the second floor façade. The bust of Benjamin Franklin takes the place of prominence at the center. Its sculptor, Frederick Wellington Ruckstull, who also executed the busts of Goethe and Macauley, thought of Franklin as "one of the greatest men of this country, and as a writer and philosopher the patriarch"

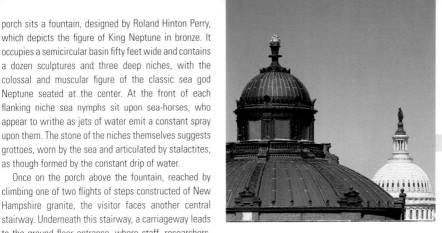

< The domes of the Jefferson Building (front) and the Capitol.

< The Neptune fountain at twilight.

of the group. The remaining six busts are of Demosthenes, Sir Walter Scott, and Dante, sculpted by Herbert Adams, and Ralph Waldo Emerson, Washington Irving, and Nathaniel Hawthorne, by Jonathan Scott Hartley.

The three ornately decorated sets of bronze doors create visual interest in the west façade. They have a combined weight of three-and-a-half tons, while each door is fourteen feet high to the top of the arch and seven-and-a-half feet wide. The doors to the left and

> Plan for the stonework of the west front.

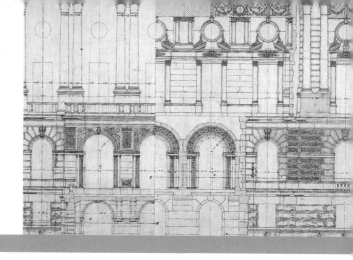

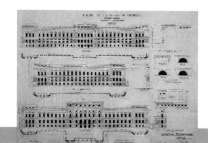

∧ Architectural rendering for three of the façades of the Jefferson Building.

right, both designed by Olin Levi Warner, symbolically portray "Tradition" and "Writing", while the lunette above the center door, designed by Frederick MacMonnies, depicts "The Art of Printing". Together they describe the progression of humanity's effort to preserve its religion, literature, history, and science. The lunette of Warner's *Tradition* shows a mother instructing her son in the lore and deeds of his forefathers, while a

Native American, a Norseman, a prehistoric man, and a shepherd, all representing pastoral peoples who preserved their histories orally, listen from either side. The female figures on the door panels below the lunette represent "Imagination" and "Memory", the traditional tools of history and literature. The lunette of *Writing* follows a similar design, with a female figure reading to children from a scroll. Four figures represent the peoples

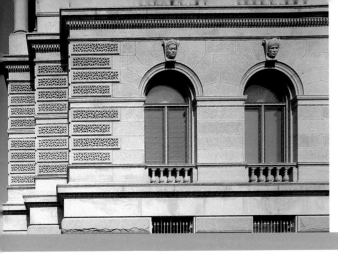

< View of the quoins (blocks of stone forming the corners of the building). The stones of each floor are treated differently: rock-faced at the basement level, vermiculated ("worm-holed") for the first story, and smooth on the second story.

who have influenced the world through writing: the Egyptian and the Jew to the right; the Christian and Greek to the left. Below this lunette, on the door proper, the two female figures symbolize "Truth" and "Research", with "Research" holding the Torch of Learning, as seen atop the dome of the Jefferson Building. MacMonnies titled the composition for his lunette over the center door *Minerva Diffusing the Products of Typographical Art.* Minerva, the Roman goddess of wisdom, is a suitably symbolic presence for the main portal to this great library, and her image will appear again within the building. The overall themes of the west façade of the Jefferson Building—knowledge and the seemingly divine power that comes from its preservation and dissemination—prepare the visitor for the treasures of scholarship that lie inside.

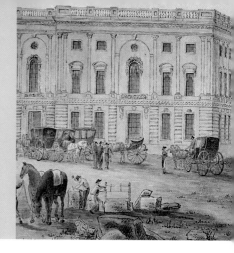

The Birth of a Building

When the new Library of Congress building opened its doors for the first time in 1897, it was described as "the largest, the costliest, and the safest" library building in the world. Prior to the existence of the Jefferson Building, fire twice destroyed significant portions of the collection, then in the U.S. Capitol. Size was consistently a major issue, as any temporary expansion of the facilities soon filled with more books than the limited space could handle. Though it was costly, the American public paid for the construction of this Library through congressional appropriations. The designers and builders performed admirably to spend less than the budgeted cost, but, nevertheless, fulfilled their duty to the public by creating an institution intended to serve as the American national library and by filling it with architecture and decoration that both expressed and enhanced this fundamental purpose.

Much of the credit for the impetus to create a new

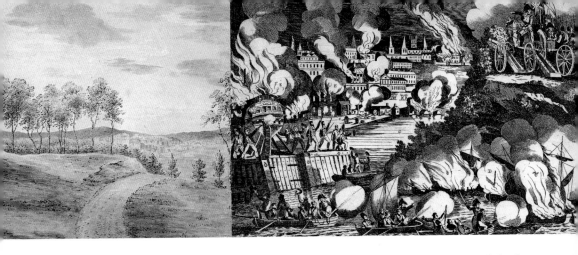

building goes to the energetic Librarian of Congress at that time. Ainsworth Rand Spofford, Librarian from 1864 to 1897, transformed the Library from a legislative institution to one that served the American public. This wider purpose had not formed part of the original establishment of the Library. In 1800, an act of Congress moved the seat of government from Philadelphia to the new capital, Washington. At that time a reference library "of books... for the use of Congress" was also legislated.

∧ *The Taking of the City of Washington in America* dramatizes the 1814 British attack on Washington, in which "public property destroyed amounted to Thirty million of Dollars." "L" marks the Capitol with smoke billowing out of it. Wood engraving by G. Thompson, 1814.

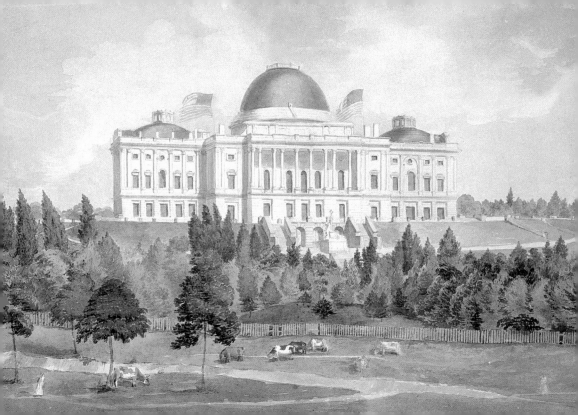

< *West Front of the Capitol, ca. 1828*, watercolor by John Rubens Smith. It shows the dome as constructed by Charles Bulfinch. The almost pastoral scene seems far from the Industrial Revolution which was then transforming northern U.S. cities.

< Part of Thomas Jefferson's surviving library in the Rare Book and Special Collections Division, with, in the foreground, an open volume by the Renaissance architect Palladio. Jefferson used Palladio's *The Four Books of Architecture* as a source for the designs of his home, Monticello, and the University of Virginia.

That library occupied space in the Capitol Building from 1800 until August 1814, when the British set fire to the building, virtually destroying the Library. The very next month, September 1814, former President Thomas Jefferson wrote a letter, from his home at Monticello, offering to sell his collection of books to reestablish the Library in its temporary Capitol facility. In the letter, forwarded to Congress, Jefferson detailed the time he spent in Paris, "examining all the principal bookstores... and putting by everything which related to America, and indeed whatever was rare and valuable in every science," eventually amassing a collection "valuable in science and literature generally, extending more particularly to whatever belongs to the American statesman." After purchasing the 6,487-volume collection for $23,950, the government also designated temporary space in the Capitol for the books and hired a full-time Librarian, separating the job from the Clerk of the House for the first time.

By 1824, the Library occupied a room in the new Capitol's west front and remained there despite fires in 1825 and 1851, the latter of which destroyed 35,000 of

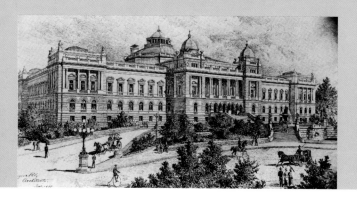

The old Congressional Reading Room in the Capitol in a watercolor by W. Bengough, as published in *Harper's Weekly*, February 27, 1897. Librarian Ainsworth Rand Spofford is depicted at far right in front of a wall of books, attempting to cope with the Library's burgeoning collections.

Smithmeyer & Pelz's design for the new Library of Congress Building. Disputes over the nature of the institution set statesmen, architects, builders, and book-lovers against one another for a seemingly endless eleven years.

the 55,000 volumes then held. The space was expanded in 1866, under pressure from Spofford, but this proved insufficient as the Library was acquiring materials more rapidly than it could house them. The real problem began in 1870 when Spofford successfully centralized all U.S. copyright activity at the Library. The new law brought almost 20,000 items into the Library in its first year, forcing Spofford to begin a vigorous campaign for a separate building. In his annual report of 1872, he argued the "absolute necessity of erecting a separate building," detailing "three ruling considerations" for that building: "fireproof materials in every part, the

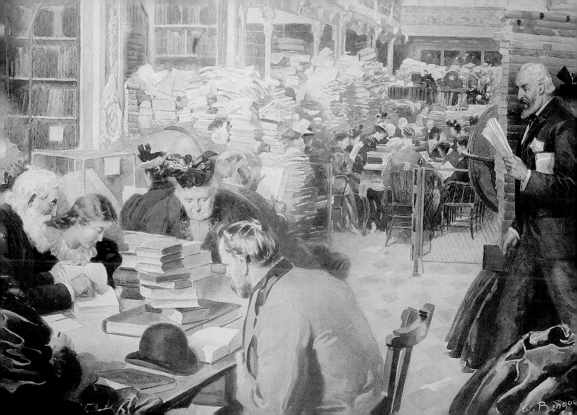

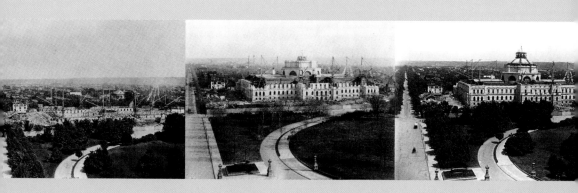

∧ The building rises, as seen from the vantage point of
the dome of the Capitol, photographed respectively in
1890, with extensive stonework under way; in 1892,
showing the drum of the central dome; and in 1894,
with half the crowning cupola completed.

highest utility and convenience in the arrangement of details, and the wants of the future." In 1873, Congress appointed a commission to review plans for a new building and it then selected an Italian Renaissance design submitted by the firm of Smithmeyer & Pelz of Washington.

Despite this decision, Congress reopened the competition to additional designs in 1874; Smithmeyer & Pelz resubmitted their plans, with only slight alterations. The matter was not settled until 1886, when Congress finally approved the Smithmeyer & Pelz design and appropriated $35,000 for the purchase of the site directly across First Street from the Capitol. Excavation began in 1887, overseen by a three-man commission and with John Smithmeyer as supervising architect. Smithmeyer, however, became involved in several controversies as architect, including allegations that he had "padded" the construction payroll and deceived Congress with low-cost estimates. In late 1888, Smithmeyer was fired, the three-man commission was abolished, and construction was placed under the direction of Brigadier General

Thomas Lincoln Casey, chief of the U.S. Army Corps of Engineers and the man responsible for the completion of the Washington Monument. Under Casey's management, and with day-to-day operations supervised by civil engineer Bernard Richardson Green, construction began in 1889. Green's contributions to the Library included the design of the tunnel for sending books back and forth from the Capitol and the construction of nine-tiered steel bookstacks, serviced by one of the first efficient pneumatic-tube-and-conveyor systems in America.

Though Smithmeyer's original plan called for the Library to be generally "void of lavish ornamentation," the construction costs fell significantly short of the original appropriation. When it became apparent in 1892 that additional funds would be available, Casey and Green seized the opportunity to turn an already remarkable building into a cultural monument. They commissioned twenty sculptors and nineteen painters—all American citizens—to embellish the structure. Casey and Green honored Spofford, one of America's best-known librarians, with the opportunity to select the

> Students and their teachers study one of a series of painted lunettes in the north corridor entitled *The Family* by Charles Sprague Pearce. Each of the six idealized scenes in the series features themes of healthy family life.

< The completed Library of Congress Building as captured in a souvenir postcard from the opening of the building in 1897. Visitors' reactions to the splendors of the building ranged from "simply magnificent" to "the grandest in the world."

subject matter for the building's iconography as well as many of the quotations for the walls and ceilings. With prodding from Green, who reminded the artists that they were "believed to be sacrificing something for the opportunity afforded them," all of the decorations were finished and installed for a cost of $364,000. The building was completed for a sum of $200,000 less than the total congressional authorization of $6.5 million.

In November of 1897 the building opened, at long last, to tremendous public reception, drawing immediate comparisons to similar institutions in Europe. The Library was soon recognized as a national showplace, elevated from its status as a collection serving Congress. After thirty-three years as Librarian of Congress, Ainsworth Rand Spofford stepped down from his post and became chief assistant librarian in 1897, secure in the knowledge that the national library, for which he had "appealed, argued, and prayed", was a reality.

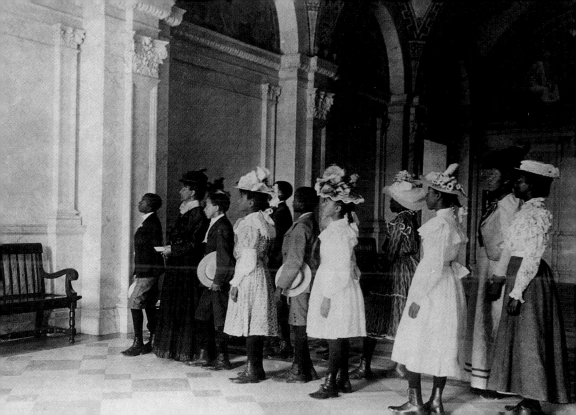

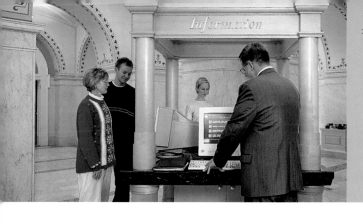

Information

> The Bob Hope Gallery of American Entertainment, showcasing some artifacts from the collection of the esteemed American icon and from the Library's music, theater, film, and dance curatorial divisions.

The Ground Floor

∧ The Visitors' Center, where volunteers and computer kiosks offer detailed information about the Library. Docents meet visitors here to give them a tour of the most ornate and highly decorated of the three Library buildings.

Visitors to the Library of Congress enter the Jefferson Building on the ground floor level. There, a modern Visitors' Center with computer terminals provides all manner of information about the Library. This update to the Library's services came as part of an $81.5 million renovation completed in 1997. The massive undertaking served both to modernize the facilities and to restore and preserve the building's more than century-old art. By the 1970s the increased number of employees at the Library had resulted in corridors and pavilions being converted into office space, with makeshift partitions and dropped ceilings that concealed murals and other decorations overhead. A congressional appropriation allowed renovation to begin in 1986. However, the work, carried out in two major phases over a dozen years, did not force the nation's greatest depository of knowledge to close. Instead, the Architect of the Capitol and the Library of Congress cooperated to ensure that the work would not disrupt library services and that at least half of the building would remain functioning throughout the construction.

The north side of the ground floor level is dedicated to exhibition and performance spaces. The Swann

< The Swann Gallery for Caricature and Cartoon displays part of the Caroline and Erwin Swann Collection of political satire and animated art.

Gallery for Caricature and Cartoon contains a revolving selection of animated art and political satire, while the George and Ira Gershwin Room houses a permanent exhibit on the work and lives of the musical team. The Bob Hope Gallery of American Entertainment provides a showcase for pieces from the beloved American icon's own collection and the Library's music, theater, and dance collections.

Across from these exhibits are the performance spaces of the Jefferson Building: the Coolidge Auditorium and the Whittall Pavilion. Situated in one of the building's four courtyards, the Coolidge Auditorium, established by a donation from the patron Elizabeth Sprague Coolidge, opened in 1925. Her namesake foundation serves to promote the "study and appreciation of music in America," by hosting free public concerts and other performances in the 511-seat theater. The Coolidge Auditorium hosted the country's oldest chamber music broadcast series, beginning with live broadcasts in 1933.

Adjacent to the auditorium, the Whittall Pavilion was built to house a gift from another Library patron. In 1935,

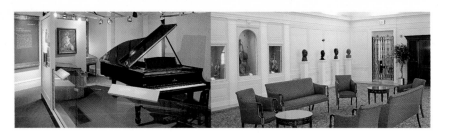

> The Coolidge Auditorium with the Juilliard String Quartet (inset) pictured here in rehearsal, which is the Library's premier performance space.

∧ The George and Ira Gershwin Room, offering a permanent exhibit of music, manuscripts, correspondence, scrapbooks, desk, piano, self-portraits, and a video documentary of the American composer-lyricist team.

∧ The Whittall Pavilion houses the Library's quintet of Stradivari instruments, donated by Gertrude Clarke Whittall, here shown exhibited in cases on the wall when they are not being used in performance.

Gertrude Clarke Whittall offered the Library a collection of rare instruments: three violins, a viola, and a violoncello all made by Antonio Stradivari in the seventeenth and eighteenth centuries. In addition, Mrs. Whittall's gift included funds to start a chamber music ensemble with the stipulation that the donated instruments be played regularly. The Whittall Pavilion offers free chamber music performances by artists-in-residence, such as the Budapest String Quartet, the Juilliard String Quartet, and the Beaux Arts Trio. While the Visitors' Center provides "the lay of the land," the exhibition and performance spaces serve to uphold the institutional commitment to the preservation and presentation of knowledge.

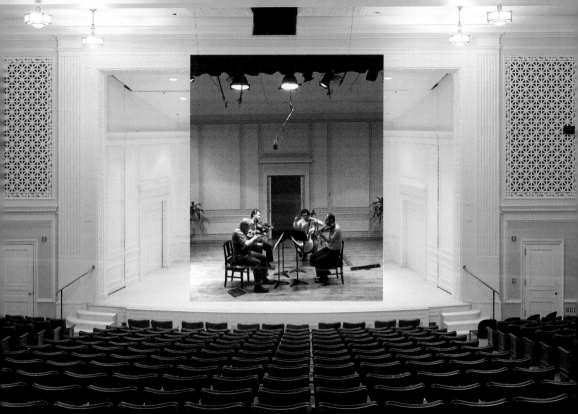

The First Floor

∧ Detail from the lunette
of *Lyric Poetry*.

The Vestibule on the first floor of the Jefferson Building is reached via a staircase from the ground level. Dazzling white marble and an ornate stucco ceiling, embellished with gold leaf, set an opulent tone. Adorning the archways, eight pairs of statues of the goddess Minerva, clad in classically styled robes, represent war and peace. The Minerva of War holds a sword in one hand and the Minerva of Peace holds a globe, while each also carries in the other hand either a torch or a scroll. These symbols of knowledge occur throughout the Library as a unifying theme. Under these archways, and into the Great Hall, a white Italian marble floor, inset with bands and geometric patterns of brown marble from Tennessee, contains numerous brass inlays. Around the border of the space the twelve signs of the zodiac alternate with rosettes, each figure set in either a square or circle of mottled red French marble, and then bordered by white Italian marble. At the center of the design is a brass sun marked with the four points of the compass, coinciding with the main axes of the building, helping to orient the visitor. Moving out into the Great Hall one sees Olin Levi Warner's triumphal arch commemorating the erection of the Library. The names of those chiefly involved in the design and construction of the building are inscribed in gold above this arch. Two stairways decorated with marble sculptures by Philip Martiny ascend to the second

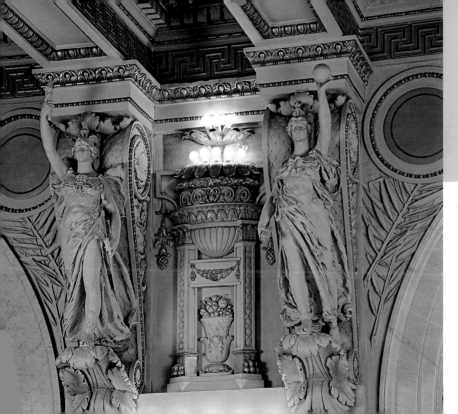

< A series of pairs of
three-foot tall plaster
statues, the Minervas of
Peace and War by
Herbert Adams, perch
upon brackets in the
dazzling white and gold
entrance vestibule.

The Great Hall

∧ Bust of Thomas
Jefferson by
Jean-Antoine Houdon.

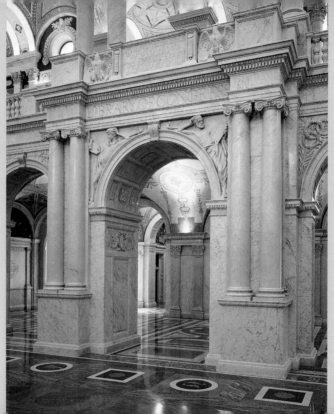

> Set into the ceiling, two
stories (75 feet) above
the floor in front of the
Commemorative Arch,
is an ornate, six-
paneled, stained-glass
skylight, in a blue and
yellow scale pattern
that echoes the design
of the floor decoration
beneath.

< The Commemorative
Arch by Olin L. Warner,
with "Library of
Congress" inscribed
above the arch in gold
letters, celebrates the
completion of the
Thomas Jefferson
Building. Two marble
figures representing the
young and the older
scholar lounge on either
side of the arch.

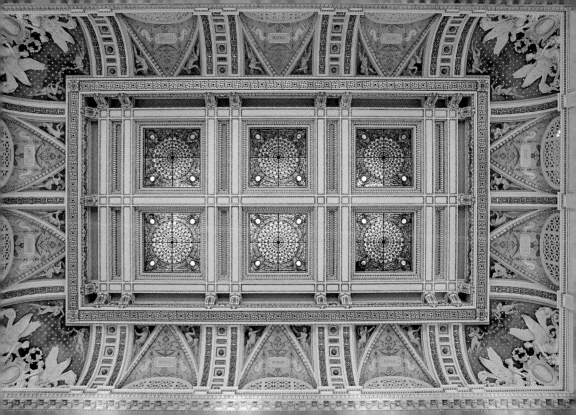

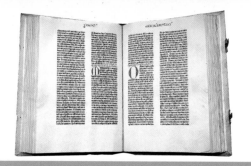

floor. Halfway up each staircase cherubic figures represent the four continents. On the south stairway a pair of boys typifies Africa and America while on the north stairway sit the figures of Europe and Asia. Each pair playfully leans on a globe that has been turned to the part of the world the children personify. In addition, symbolic items surround each figure. Europe, for example, sits with an Ionic column over his left shoulder while a lyre and a book lie by his lap, symbolizing architecture, music, and literature.

The east corridor of the first floor houses two of the Library's great treasures, each on permanent display. The Giant Bible of Mainz occupies the north end of the corridor, while the south end features the Gutenberg Bible which, dating from 1454 or 1455, was the first book printed with movable metal type in the western world. The two hundred or so bibles published by Gutenberg sparked a revolution in literacy. American libraries hold nine of the fifty or fewer extant original Gutenberg Bibles dispersed around the world. The Library of Congress, however, holds one of only three perfect copies printed on vellum (parchment made from calfskin). Appropriately, the British Library in London and the Bibliothèque Nationale in Paris, two institutions that served as inspirations for the Library of Congress, possess the others.

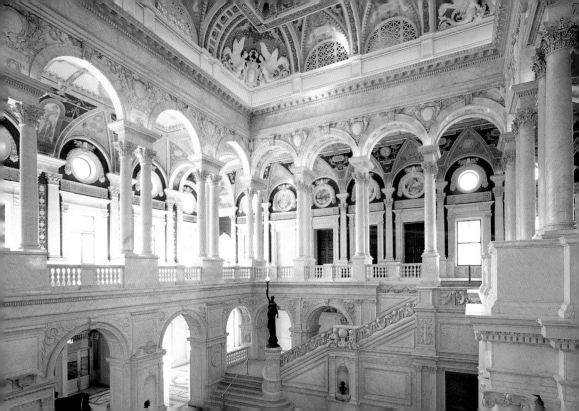

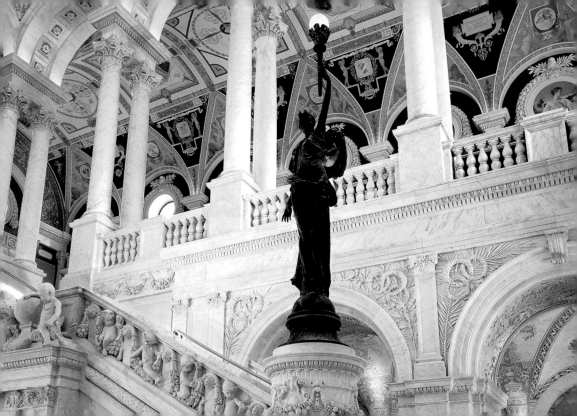

< An eight-foot-tall, bronze newel-post torchbearer raises her lamp of learning over the staircase that leads to the Library's splendid second floor. The most fanciful of Martiny's sculptures are the numerous, antic marble babies that decorate the staircase railings, representing various occupations.

< The south corridor of the first floor is called the Hall of Heroes, and contains murals by Walter McEwen illustrating Greek myths like those of Theseus, Achilles, and Hercules.

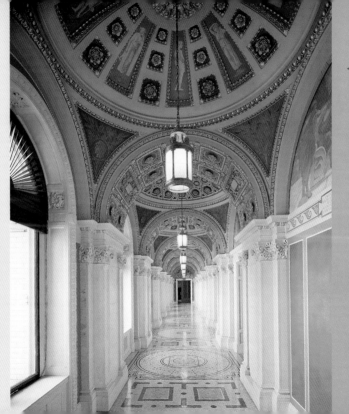

First Floor Lunettes

The north, south, and east mosaic corridors are decorated with the names of Americans associated with various fields of knowledge, the names of the Librarians of Congress, and with four mural series on a variety of themes.

∧ The central panel of Henry O. Walker's lunettes in the south corridor is *Lyric Poetry*. The form is represented by a young woman with five handmaidens and one male youth embodying different inspirations for her poetry, including truth, passion, and beauty.

∧ John White Alexander's *The Evolution of the Book* series in the east corridor shows the development of communication from the earliest days of the use of cairns. *The Manuscript Book* shows a medieval monk laboriously copying a manuscript into a great folio.

Six paintings by John White Alexander in the east corridor make up a series titled *The Evolution of the Book*. On the south end, *The Cairn* depicts a group of prehistoric men raising a heap of stones, followed by *Oral Tradition*, showing an Arabian storyteller, and *Egyptian Hieroglyphics*, in which an Egyptian workman carves an inscription over a temple door. The north end begins with *Picture Writing*, in which a young Native American applies red paint to a smoothed deerskin, followed by *The Manuscript Book* with an image of a

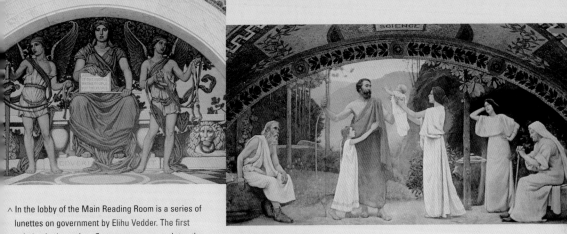

∧ In the lobby of the Main Reading Room is a series of lunettes on government by Elihu Vedder. The first painting in the series, *Government*, encapsulates the ideals of good government and includes an inscription from Lincoln's Gettysburg Address on a tablet held by the seated female figure.

∧ In the north corridor, Charles Sprague Pearce's series of six lunettes deals with aspects of family life. *The Family*, the central panel, depicts a father's return and welcome by his parents, wife, and children.

cloistered monk laboriously illuminating the pages of a large book, and finally, *The Printing Press*, where Alexander has depicted Gutenberg himself at work in his shop, producing the very book on display nearby.

All of this grandeur, however, merely sets the stage for the Main Reading Room, the jewel of the Library of Congress, positioned directly under the dome. The Main Reading Room is a functional monument to the world of knowledge, and the American library's role in preserving it. Within the octagonal shape of the room are eight two-

The Main Reading Room

The octagonal room is 160 feet from the floor to the top of the domed ceiling of the lantern and 100 feet wide. Massive piers with engaged columns create 8 bays or alcoves, each with its own marble screen. The arches support a circular entablature—the top section of the columns— from which springs the room's great dome.

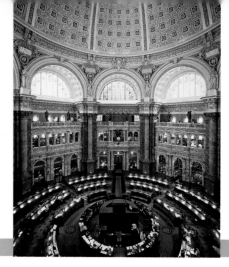

< The Jefferson Building's great dome soars above the Main Reading Room.

> The state seal windows, set into the drum of the dome, shed light on a reader at a desk.

story alcoves, each separated by massive piers. Sixteen statues adorn the balustrade of the galleries above the alcoves and John Flanagan's clock with bronze sculptures. The figures are grouped in pairs according to their respective areas of contribution to civilization: religion is represented by Moses and Saint Paul; commerce by Christopher Columbus and Robert Fulton; history by Herodotus and Edward Gibbon; art by Michelangelo and Ludwig van Beethoven; philosophy by Plato and Francis Bacon; poetry by Homer and Shakespeare; law by Solon and Chancellor Kent; and science by Isaac Newton and Joseph Henry. Wherever possible the sculptors sought to capture realistic images of their subjects. Beethoven, for example, is shown thrusting his hand into the air to beat the measure of a harmony with such fervor that he has whipped the pocket

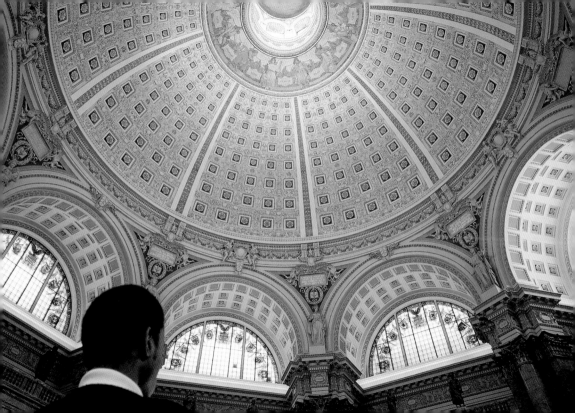

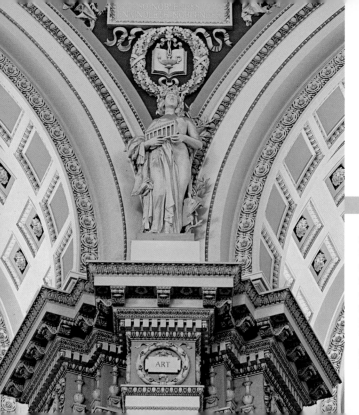

< A towering figure symbolizing "Art" holds a model of the Pantheon. The plaster statue, one of eight female figures representing aspects of civilized life on top of the engaged columns, was conceived by Augustus Saint-Gaudens and executed by Francois Tonnetti-Dozzi.

of his coat inside out. Also of interest are the horns on the head of Moses, a curious convention that crept into art because of an ancient mistranslation of the Hebrew word that describes a ray of light in Exodus. Set upon the entablature over the piers, eight female figures personify the facets of civilization embodied by the historical figures below, each group forming a symbolic triangle. "Commerce", situated between Columbus and Fulton, for example, holds a schooner in one hand and a locomotive in the other.

Above these statues, before the start of the dome

proper, a series of eight semicircular lunette windows of stained glass, designed by architect Edward Pearce Casey and decorated by artist Herman T. Schladermundt, provides most of the light needed to illuminate the entire room through 3,200 square feet of window space. Schladermundt placed the Great Seal of the United States at the top of each window, set on a white background to diffuse the sunlight. Each seal is then flanked on either side by three seals of the states and territories of the time and, finally, by Roman fasces encircled by a laurel wreath—symbols of power and victory. The forty-eight state and territory seals, excluding Alaska and the Indian Territory (later to become Oklahoma), occur in the order of their formation or admission to the Union, with the dates inscribed above each seal. Schladermundt demonstrated his notable skill as an artist by effectively creating a harmonious whole using a heterogeneous collection of designs. No seal was created with the intention of fitting into a series. Nevertheless, Schladermundt organized, and sometimes modified, these images so that they appear consistent from one seal to the next.

∧ Bronze portrait statue of Beethoven, one of sixteen statues of illustrious men who each symbolize a particular form of endeavour—from Art to Law to Science.

> John Flanagan's vivid life-size bronze statue of Father Time clutching his scythe appears to step out into the space above the handsome clock. Figures of women and children, representing the seasons, hover to the right and left of the grim reaper. Two graceful male figures lean against either side of the clock.

< Figures of two youths, one holding scissors and the other a cup, with each holding a flaming torch, form part of the main frieze.

∧ Top of a Corinthian column.

Central to the majesty of the Main Reading Room is the dome of stucco over ironwork, towering 160 feet over the busy floor. Although figures and ornamentation cover the inside surface of the dome, the plan is relatively simple. Eight ribs, patterned with gilded guilloche—an ornament composed of continuous interlaced curving lines—divide the dome into sections. Recessed panels, known as coffers, consisting of a gilded rosette set into a blue square and framed by an egg-and-dart border, repeat regularly to the top of the dome, 40 in each section, 320 in total. These coffers diminish in size from 4½ feet square at the bottom of the dome to 2½ feet square at the top. The color also lightens from a heavy shade of blue at the bottom, to a more airy, sky-like tint at the top. This use of perspective heightens the impression that the dome soars far into the sky. The bands between each coffer are completely filled with stucco relief decorations. Though the variety is staggering—lions' heads, sea-horses, dolphins, urns, cartouches, griffins, shells, storks, caryatids, tridents,

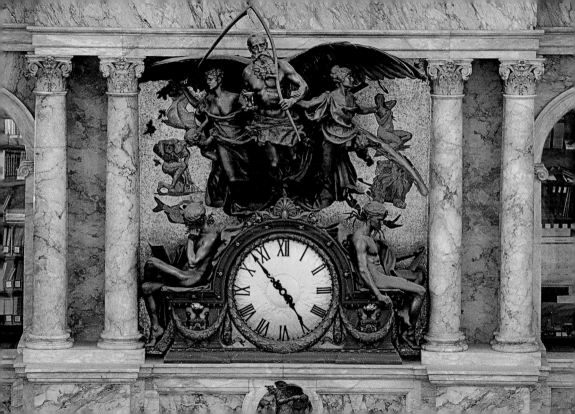

eagles, and cherubs, all circled by intricate foliage—the effect remains subtle because the figures are formed from the same white stucco as their background.

The apex of the dome, literally and figuratively the crowning glory of the building, contains Edwin Howland Blashfield paintings of *The Evolution of Civilization.* A female figure in the cupola represents "Human Understanding" lifting the veil of ignorance from her face and gazing upward. Two cherubs attend her, one holding a book of wisdom, the other offering a gesture of encouragement to the readers below. The circular mural around this image contains twelve seated figures, male and female. These evenly spaced, ten-foot high figures represent the twelve countries then thought to have contributed the most to the development of modern civilization. Beside each is a tablet inscribed with the name of a country, and below this is the name of a major contribution by that country to humanity. Circling the collar of the dome chronologically, the figures are: Egypt, typifying written records; Judea, religion; Greece, philosophy; Rome, administration; Islam, physics; the Middle Ages, modern languages; Italy, the fine arts; Germany, the art of printing; Spain, discovery; England,

literature; France, emancipation; and America, science. (The Middle Ages were thought to represent a unified Europe during the period between the dissolution of the Holy Roman Empire and Columbus' discovery of America) In several cases, Blashfield used actual people as inspirational, if not direct, models for his faces. The countenance for "America", for example, resembles Abraham Lincoln, while that of "France" suggests the features of the artist's wife. The attributes of each figure typify his or her country, time period, and representative contribution to culture. "Italy", for example, dressed in Renaissance costume, holds a palette and brush, and is surrounded by a statuette version of Michelangelo's David, a column capital, and a violin, signifying painting, sculpture, architecture, and music. The last figure, "America", is represented as an engineer lost in thought over an electric dynamo and clutching a scientific book in his hand, recalling the role of the United States in the advancement of industry. This is the setting for the thousands of readers that pass through annually to perform research into the Library's collections, and it contains no shortage of scholarly inspiration.

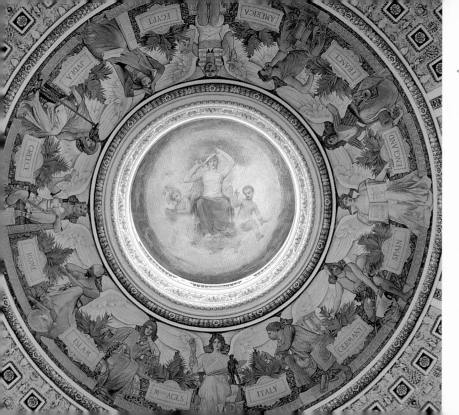

< In Edwin H. Blashfield's
mural at the apex of the
dome, a female figure,
"Human Understanding",
lifts the veil of ignorance.
Also by Blashfield, figures
representing some of the
countries that have
contributed to world
civilization circle the
surrounding collar of
the dome.

The First Floor Rooms

< The Librarian's Room:
The ceremonial office
of the Librarian of
Congress is a small
triumph of decoration.

∧ The Jefferson Congressional Reading Room, one of two rooms for use by Congress, is
an intimate space creating an atmosphere of calm. Here, a decorative lighting sconce
illuminates the finely carved oak scroll work of the walls. Throughout the room the oak is
ornamented with delicate inlaid arabesques of white mahogany. A room off the lobby is
halved by a low gallery enclosed by a delicately carved marble balustrade.

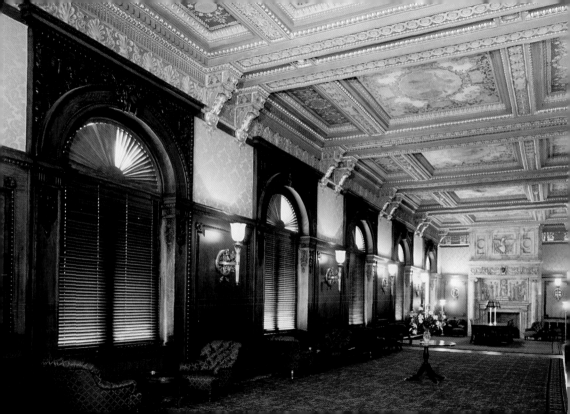

< The Members of Congress Room, the first of two rooms off the Hall of Heroes, designated for the use of Congress, is a richly decorated gallery. Oak floors and half-walls, together with a paneled ceiling with seven inset paintings, create a formal atmosphere. Two fireplaces with magnificent mantles of Siena marble hold large mosaic panels by Frederick Dielman, titled *Law* (shown right) and *History*.

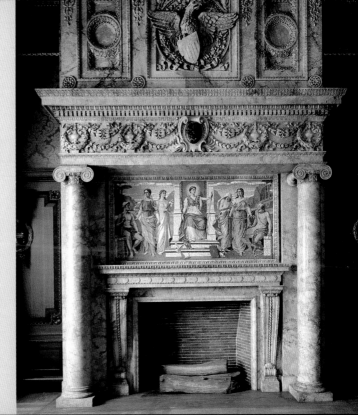

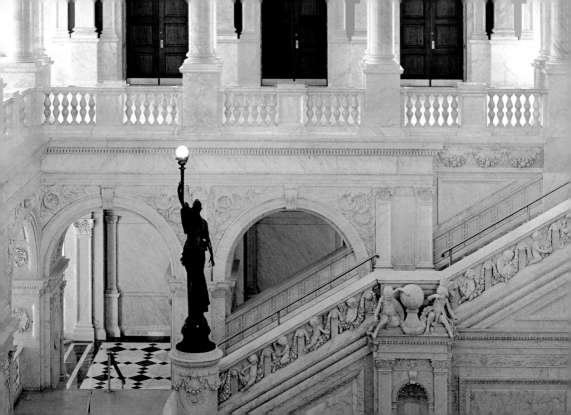

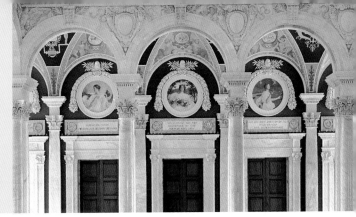

The Second Floor

The stairs from the Great Hall go to the second floor, with its four highly embellished corridors that form a square around the Hall's upper level. Printers' marks, painted on the curved triangular surfaces at the margins of the walls and ceilings, form a motif common to all four corridors. Fifty-six in all, these simple black outlines represent the engravings that printers used as informal trademarks on the title page of books. The artwork in each of the corridors depicts a unique decorative theme. In the west corridor, artist Walter Shirlaw explores the sciences with a series of eight female figures representing zoology, physics, mathematics, geology, archaeology, botany, astronomy, and chemistry. The colors of purple, blue, and red occurred most frequently in chemical experimentation at the time, hence the coloration of the figure of "Chemistry." "Astronomy", with a lens in her right hand and a globe of Saturn in her left, stands on the sphere of the earth, with a quarter moon in the background. The graceful lines of her gown suggest the orbit of heavenly bodies. At either end of the corridor is

∧ Pairs of gleaming marble columns frame circular paintings of three of the four seasons.

< A marble staircase leads from the first floor to the even more elaborate decorations of the second floor.

< In *Beauty*, Euphrosyne, one of the many daughters of Zeus and one of the three Graces in Greek mythology, contemplates her reflection in a hand mirror. Octagonal panel by Frank Weston Benson on the vault of the south corridor.

> In *Tragedy*, a woman holds an emblematic tragic mask. She is one of eight representations of genres of literature in the east corridor by G. W. Barse.

∧ *Taste*, by Robert Reid, is one of five octagonal paintings on the north corridor ceiling representing the senses.

a tablet with the names of men distinguished in the sciences, such as Nicolaus Copernicus, the astronomer, and Antoine Lavoisier, the chemist.

The west corridor leads into the north corridor, where Richard Reid's paintings of *The Five Senses* constitute the decorative theme. Octagonal ceiling images of seated female figures in softer, more contemporary

colors and brushstrokes, depart from the consciously classicized images in many of the paintings found elsewhere in the Library. "Taste", surrounded by vines laden with grapes, drinks from a shell. "Sight", smiling with pleasure, gazes at her reflection in a hand mirror, while a peacock, the symbol of beauty and pride, stands beside her. "Smell" enjoys the scent of a single white

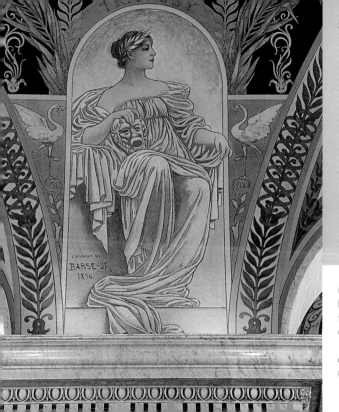

> *Knowledge*, one of four brilliantly colored circular wall murals by Robert Reid in the north corridor, is paired with the quotation "Knowledge comes but Wisdom Lingers."

rose, while "Hearing" dreamily holds a large seashell to her ear. Finally, "Touch" delights in the contrast between the light sensation of a butterfly on her arm and the feel of the fur of a dog asleep near her.

Artist Frank Weston Benson decorated the south corridor with three hexagonal panels representing the Graces and four circular panels evoking the four seasons.

> *Minerva* mosaic by
Elihu Vedder on the
second floor wall on
the landing of the
staircase leading up to
the Visitors' Gallery.

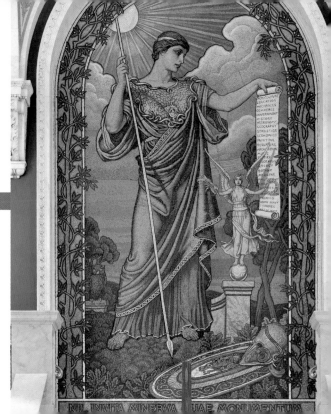

Taken together, the Graces—Aglaia, Thalia, and
Euphrosyne—typify beauty. Benson represented Aglaia
as the patroness of husbandry, with a shepherd's crook,
Thalia as music, with a lyre, and Euphrosyne as beauty,
holding a hand mirror. In addition to using symbolic
imagery, such as fruit or flowers, in the panel of the four
seasons, Benson also varied the background colors or the
faces of his female subjects, subtly rendering them
warmer or colder, as appropriate to the season.

George Randolph Barse, Jr. painted the scenes in the

> Patriotism and Courage, two of eight Pompeiian-style figures by George W. Maynard, flank a window below a magnificent rinceau, or motif of acanthus leaves, in the north corridor. Another pair of *Virtues* is reflected in the kaleidoscopic marble mosaic floor beneath the tableau.

east corridor, choosing figures to personify the eight genres of literature. Each female figure appears dressed in classically styled robes, with some aspect of a genre. "Lyric Poetry", for example, plays a lyre, while "Tragedy" holds the traditional mask of drama. The east corridor also provides access, via a staircase, to a viewing gallery that overlooks the Main Reading Room. On the first landing of the staircase, set onto a panel fifteen-and-a-half feet high and nine feet wide, is Elihu Vedder's marble mosaic portrait of the Minerva of Peace. She has cast off her armor and to her right is the statue of Victory, to her left an owl. At the top of the mosaic, dark clouds roll away as the sun, signifying renewed prosperity, sends its rays in all directions. Minerva's gaze rests on a scroll, inscribed with various areas of learning, including law, biology, and philosophy. The inscription below the mosaic is from Horace's *Ars Poetica: Nil invita Minerva, quae monumentum aera perennius exegit* (Not unwilling, Minerva raises a monument more lasting than bronze).

The Second Floor Rooms

∧ The Rare Book and Special Collections Reading Room contains some 800,000 items, ranging from pamphlets, broadsides, and books, to medieval and Renaissance manuscripts, growing from the nucleus of Thomas Jefferson's personal library.

∧ The Lessing J. Rosenwald Room, opposite the reading room, is modeled on Mr. Rosenwald's study in Pennsylvania and contains his reference collection. The Rosenwald collection itself, comprising 2,653 illustrated books from the fifteenth through the twentieth centuries, is housed in the Rare Book vaults.

∧ The Woodrow Wilson Library Room contains many of the President's books and is often used for scholarly lectures.

< The African and Middle Eastern Division Reading Room makes available to readers material from the Division's varied collections.

∧ In the Hispanic Reading Room, in the southeast gallery, a researcher consults the reference collections, the primary access point for research into the Caribbean, Latin America, Spain, and Portugal.

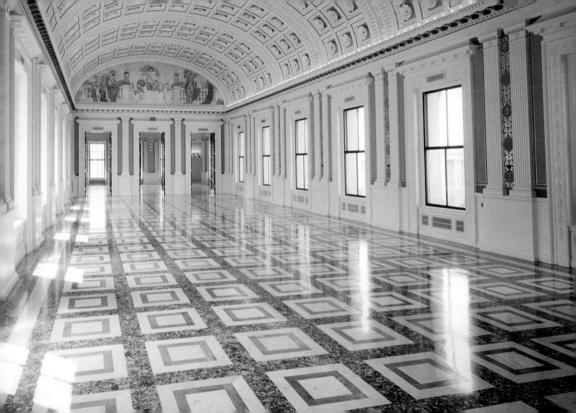

The Galleries

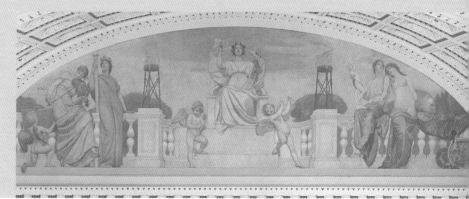

< A long view of the southwest gallery, often the site of exhibitions. One of the two lunettes by Kenyon Cox, *The Sciences*, is visible at the end of the Gallery and a second, *The Arts*, shown in close-up, is on the opposite wall.

From these corridors a series of galleries continue all the way around the second floor. Intended for exhibitions, the two west galleries are the most lavishly decorated. The lunettes painted by Kenyon Cox at each end of the southwest gallery are of particular note. The images are each thirty-four feet long by nine-and-a-half feet high. At the south end is *The Sciences* and at the north end, *The Arts*. In *The Arts*, a central throne is occupied by the figure of "Poetry", represented as a beautiful young woman crowned with laurel and bearing an antique lyre. Two winged cherubs accompany her, one of whom is writing down the words of her song. To either side of the lunette are personifications of "Architecture", "Music", "Sculpture", and "Painting", each bearing an appropriate object. In *The Sciences*, the central figure is "Astronomy", holding a pair of compasses and leaning

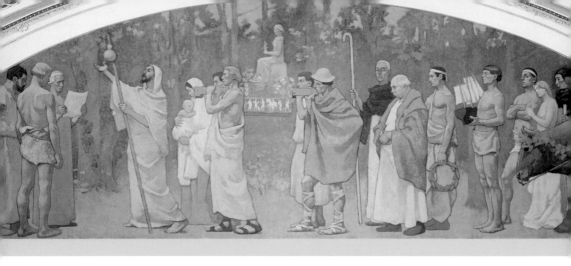

∧ The northwest gallery, which contains Gari Melchers' murals *Peace* on the south wall and *War* on the north wall, is another highly decorated and light-filled space used for exhibitions.

forward on her throne to make measurements upon a globe. The right side of the panel portrays "Botany" and "Zoology" while the left depicts "Physics and Mathematics", herself instructing a cherub using an abacus, the beads of which give the date 1896—the year of the painting.

In the northwest gallery are murals, painted by Gari

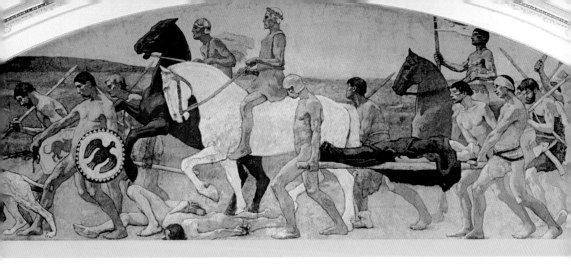

Melchers, representing peace and war, the same subjects he chose for his paintings at the World's Columbian Exposition of 1893 in Chicago. In the panel *War*, at the north end of the room, a chieftain returns home with his tribe after a successful battle. He wears a wreath of laurel and sits proudly upon a white horse, but the toll of war is apparent. His men, including the weak and wounded, are seen stepping over a pair of corpses. Peace depicts an early religious procession where the inhabitants of a village, bearing the image of a goddess, have come to a grove, while a priest reads a blessing.

At each corner of the Library is a pavilion, connecting one gallery to the next. Occupying the northwest corner, in the Pavilion of Art and Science, are four murals painted

Northwest Pavilion: The Pavilion of Art and Science

> Half of the Pavilion of Art and Science, showing two of the four lunettes by William De Leftwich Dodge, separated by a bas-relief, with a view into the northwest gallery at right.

> *Ambition*, the ceiling disc of the northwest pavilion by William De Leftwich Dodge.

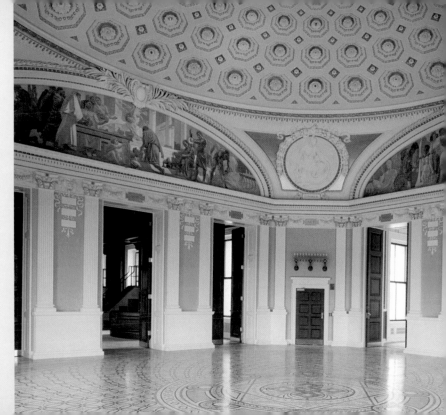

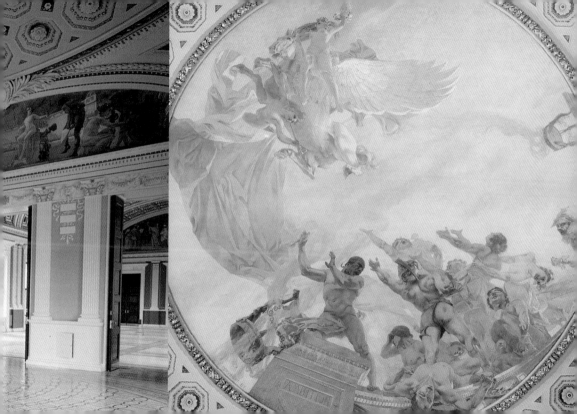

Northeast Pavilion: The Pavilion of the Seals

> The ceiling disc is the Great Seal of the United States, surrounded
by a band of forty-eight stars, one for each state and territory at the
time. Four medallions contain heads symbolizing the four winds.
Garlands hang beneath the blowing winds and many other
representational objects such as lyres (fine arts), and horns of
plenty (agriculture), complete the design of the disc. Abraham
Lincoln's words from the Gettysburg Address frame the disc's edge:
"That this nation, under God, shall have a new birth of freedom;
that government of the people, by the people, ... for the people,
shall not perish from this earth."

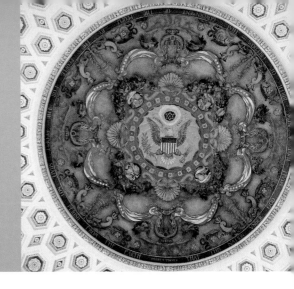

by William De Leftwich Dodge, with the subjects
literature, music, science, and art. The ceiling painting,
titled *Ambition*, also by Dodge, depicts a group of
swirling, pale figures set against a white sky that have
climbed to the top of a mountain but reach further. Their
"Unattainable Ideal" rides through the air on a great
winged horse, mockingly holding out the palm branch of
complete achievement. None of the mass below, some
distracted by crime or lust, can reach the figure on the
horse, and a jester, holding a skull in one hand and a
statuette of victory in the other, suggests the moral that
fame comes only after death.

On the northeast corner of the building is the Pavilion
of the Seals, enhanced by the paintings of William

**Southwest Pavilion:
The Pavilion of the
Discoverers**

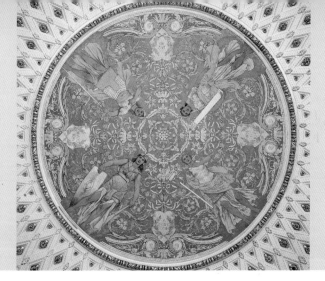

< The Discoverers ceiling
disc depicts the four
qualities most
appropriate to a
country's development:
Adventure, Discovery,
Conquest, and
Civilization. By George
W. Maynard

Brantley Van Ingen and Elmer Ellsworth Garnsey. Van Ingen's four lunettes illustrate the seals of the various executive departments of the United States Government. Each is devoted to two departments: the Departments of State and the Treasury; Justice and the Post Office; Agriculture and the Interior; and War and the Navy. In the background, behind the seal of the Treasury Department, Van Ingen depicts two children playing on the parapet of the Treasury Building, one of them with his foot on a strong box. Each lunette has an appropriate quotation. Inscribed below the seals of the Agriculture and Interior Departments, for example, is Andrew Jackson's quotation, "The Agricultural interest of the country is connected with every other, and

Southeast Pavilion: The Pavilion of the Elements

> Robert Leftwich Dodge's *The Elements*, a ceiling disc featuring Apollo. The signs of the zodiac at the outer edge are by Elmer E. Garnsey.

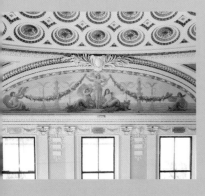

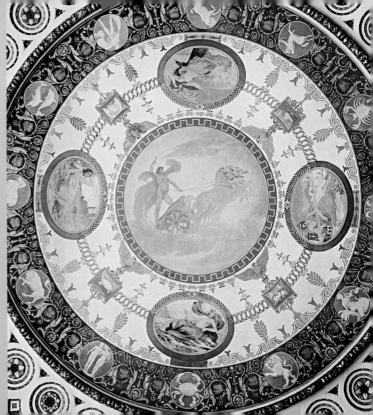

∧ View of *Water*, one of Robert Leftwich Dodge's four tympanums in the pavilion, which include *Earth*, *Air* and *Fire*.

superior in importance to them all." In the center of the dome's ceiling Garnsey depicts the Great Seal of the United States, putting the final touch on the significance of the lunette paintings. Encircling the seal is a band of forty-eight stars, reminiscent of the state seals found in the Main Reading Room.

In the southwest pavilion, artist George Willoughby Maynard creates a painted tribute to the stages of a country's development: adventure, discovery, conquest, and civilization. The lunette paintings progress from the figure of "Adventure", holding a drawn sword and a caduceus, the emblem of Mercury, god of travelers, to "Discovery", holding a rude map of America, and to "Conquest", bearing emblems of victory, to "Civilization", the flowering of the previous three. The central figure in *Civilization* has cast aside her armor and holds aloft the torch of learning, while displaying an open book. The ceiling disk, also by Maynard, portrays representations of four qualities associated with these stages: courage, valor,

fortitude, and achievement. "Fortitude", for example, holds an architectural column, a symbol of stability.

The artwork in the southeast pavilion contains representations of the four elements: earth, air, fire, and water. Robert Leftwich Dodge painted the four lunettes and the ceiling disk. Male figures represent earth and fire, with female figures as air and water. In the lunette of *Earth*, the idea is the fertility and bounty of the soil. Among the figures surrounding the personification of earth, one holds a wine jar and a rose, while another reaps grain. Beneath this lunette the artist inscribed the names Demeter, Hera, and Dionysus, deities associated with the harvest, the earth, and wine. In *Water*, the central figure, clad in green, holds garlands of seaweed and water lilies. Flanked by mermaids, and set against the open sea, the scene also includes a galley decorated with the type of standards erected in honor of victorious Roman admirals. The ceiling disk repeats the theme of the four elements, here revolving around the central

> The northwest pavilion was the site for an exhibition of the surviving original volumes from Thomas Jefferson's library.

figure of Apollo, representing the movement of the sun as he drives his four-horse chariot across the sky. Connected by a circular chain, Dodge's medallions of the elements and cartouches alternate with each other. The medallion representing fire depicts a reclining woman, burning incense as Mount Vesuvius sends out a steady cloud of smoke in the distant background. The cartouche for this scene contains a simple lamp, while the cartouche paired with *Earth* contains a tortoise, the creature that supported the earth on its back, according to Hindu mythology.

The richness of the nineteenth century art that decorates the spaces of the Jefferson Building parallels the wealth of the Library's collections. It is the Library's

A few facts and figures about the Jefferson Building

The original building, costing $6,345,000, contained:

104 miles of shelving

409,000 cubic feet of granite

500,000 enameled bricks

22,000,000 red bricks

3,800 tons of steel and iron

73,000 barrels of cement

2,165 windows

15 varieties of marble

Today

600,000 square feet of floorspace.

10,000 new items added to the collections each working day

532 miles of shelving (the general collections occupy 257 miles of them)

The Jefferson Building Timeline

1870	First Proposal December 1872
1880	Congressional authorization April 1886
	Clearing of site begins October 1886
	New plan approved March 1889
	Foundation completed September 1889
1890	Cornerstone laid August 1890
	Dome completed December 1893
	Superstructure completed July 1894
	Mural paintings completed February 1897
	Building opens November 1897
1980	Building named for Thomas Jefferson June 13, 1980

mission in the digital age to provide this wealth to people across the country and around the world. In 1996, Librarian of Congress James Billington declared, "By making freely available millions of unique items from our nation's history... citizens everywhere will be able to share in the American experience." For example, the National Digital Library Program assembled a core of American historical and cultural primary source material in digital form and made it accessible to the general public and educational institutions. The on-line collections allow people in the U.S. and around the globe to grasp the complexities of American history, from the country's revolutionary beginnings to the amazing growth and changes in the nation.

For Ainsworth Rand Spofford, Librarian of Congress, without whom there would be no Thomas Jefferson Building.

Photography Credits

Front cover: Exterior of the Thomas Jefferson Building (left). Photo: Library of Congress. Minerva mosaic (right). Photo by Anne Day

Back cover: Dixieland band playing on the steps of the Thomas Jefferson Building at first annual National Book Festival in 2001. Photo by Christina Wenks/Library of Congress. Cross-section of the Jefferson Building created by Doug Stern

Architect of the Capitol: 6, 22, 30 left (ref AOC62731), 30 right (AOC67307), 31 left (AOC61127), 31 right (AOC67323), 41 main (AOC67343), 42 (AOC67339), 52 (AOC72109), 53, 54 (AOC67040), 55, (AOC61085), 56 (AOC65805), 57 (AOC67010), 58, 60 left (AOC61072), 60 right

Levon Avdoyan: 58

Reid Baker/Library of Congress: 2, 4, 11, 32

Anne Day: 23, 24 right, 25, 27, 28, 29, 34, 35 left & right, 36 left & right, 37, 39, 41 (inset), 46 left and right, 47 left and right, 48, 49 left & right

Jim Higgins/Library of Congress: 3, 19 left, 20 right, 21 (main), 50 left, 50 middle, 50 right

Carol Highsmith: 5, 7, 18, 33, 40, 43, 44, 45, 51 middle, right

Library of Congress/Prints and Photographs Division: 8 (LC-USZC4-247), 9 (LC-USZC4-4555), 10 (LC-USZC4-3579), 12, 13, 14 left (LC-USP6-6545A), 14 middle (LC-USP6-6516A), 14 right (LC-USP6-6519A), 16, 17 (LC-USZ62-4550), 19 right, 26 (LC-USZC4-4936)

David Sharpe, Inc: 62

Chad Evans Wyatt: 21 (inset)

Production Credits

Editor: Evie Righter (Library of Congress)/Howard Watson (Scala)

Designer: Roger Hammond

ISBN 1 85759 136 4

Printed in Italy

Copyright © 2003 The Library of Congress

Published by Scala Publishers Ltd in association with The Library of Congress